# The Last Tree

## A SEED OF HOPE

Luke Adam Hawker

**ilex**

An Hachette UK Company
www.hachette.co.uk

First published in Great Britain
in 2023 by ILEX, an imprint of
Octopus Publishing Group Ltd
Carmelite House
50 Victoria Embankment
London EC4Y 0DZ
www.octopusbooks.co.uk
www.octopusbooksusa.com

Design and layout copyright
© Octopus Publishing Group 2023
Text and illustrations copyright
© Luke Adam Hawker 2023

Distributed in the US by
Hachette Book Group
1290 Avenue of the Americas
4th and 5th Floors
New York, NY 10104

Distributed in Canada by
Canadian Manda Group
664 Annette St.
Toronto, Ontario, Canada M6S 2C8

ISBN 978-1-78157-870-4

A CIP catalogue record for this book
is available from the British Library

Printed and bound in Italy

10 9 8 7 6 5 4 3 2 1

There are many people behind the creation of this book.

Thank you to my family, who have had to tolerate my head
being in the book rather than the room for so many months.
Your support, understanding and pride mean so much to me.
Above all, to my wife Lizzie: I couldn't fit the list of reasons to
thank you in all 64 pages.

Thank you, Harry boy. Fatherhood has been my biggest
challenge and honour to date. You have taught me so much
and will no doubt continue to do so. I love you so very much.

Thank you to my brother John Hawker, for being my best
friend and the fantastic wordsmith you are.

Thank you to my assistant Laura Mochrie. I'm quite sure
your hard work in the studio stopped a breakdown, and your
honest input was integral to the final stages of the book.

Thank you to my young neighbour, Olive, for being the muse
and protagonist for this adventure. I hope you enjoy the book.

Thank you to the entire team behind the book at Ilex and
Octopus Publishing Group: Denise Bates, Ben Gardiner,
Rachel Silverlight, Jeannie Stanley and Caroline Alberti.
Special thanks go to Ellie Corbett, whose guidance,
experience and honesty helped develop the book into
something we can all be proud of.

Thank you to Marianne Laidlaw for introducing me to the
world of books and making *Together* the success it is.

Thank you to those who have forged a path for picture-based
books, specifically Shaun Tan and Charlie Mackesy. Your
work is an inspiration for myself and so many.

Thank you to all those who have supported my passion
for drawing and storytelling over the years. I feel so very
honoured to be filling books with my drawings, and you are
the ones who have made it possible.

Finally, thank you to all tree lovers, past, present and future.

P.S. Sorry to my dog Robin for not featuring you in this book.
I know you'll be fuming.

*For my boy, Harry*

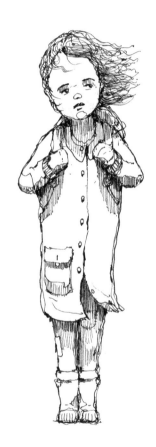

Olive was always the last to
be collected from school.

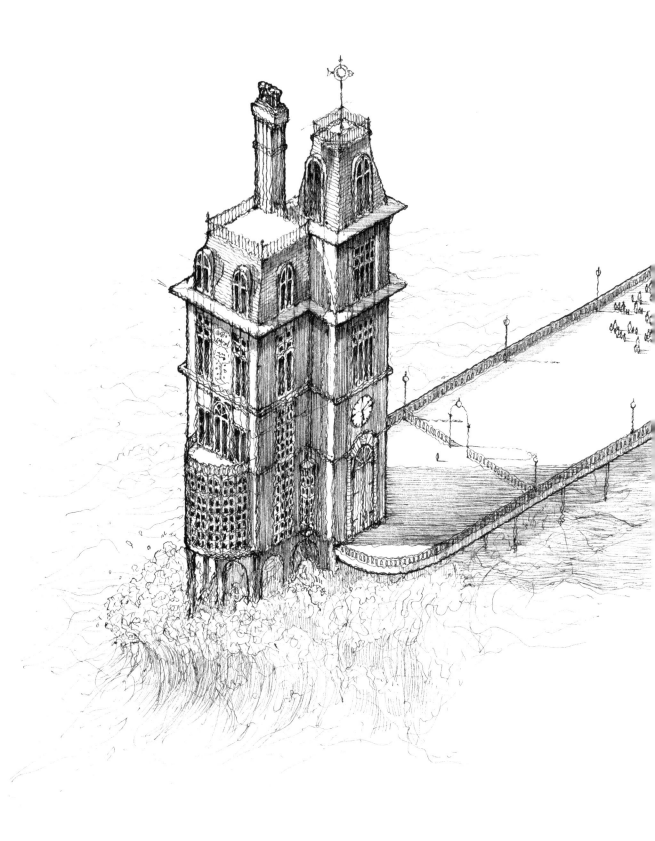

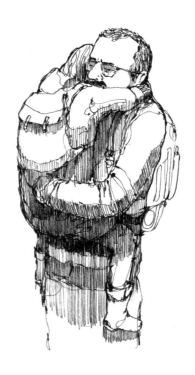

But it was always worth
the wait.

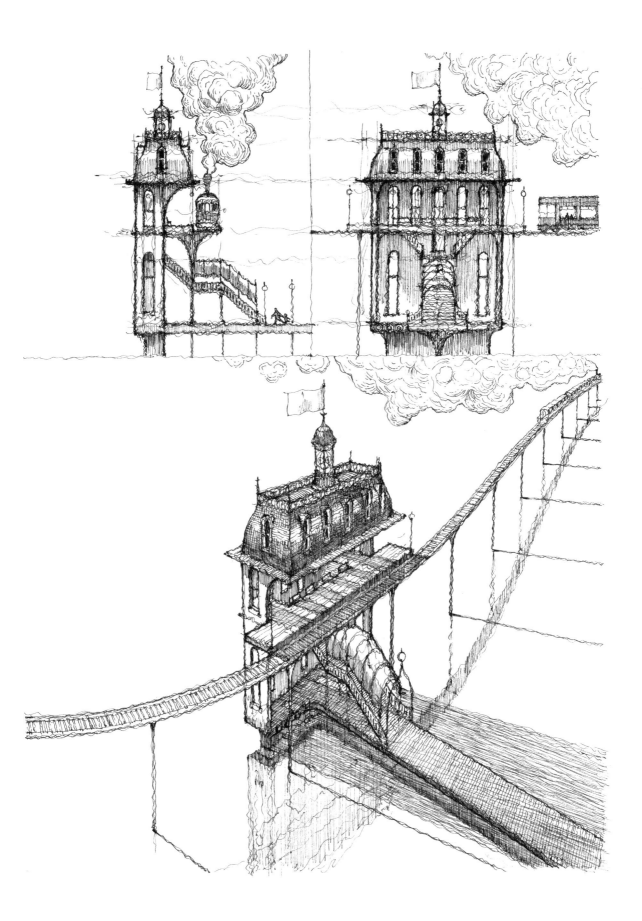

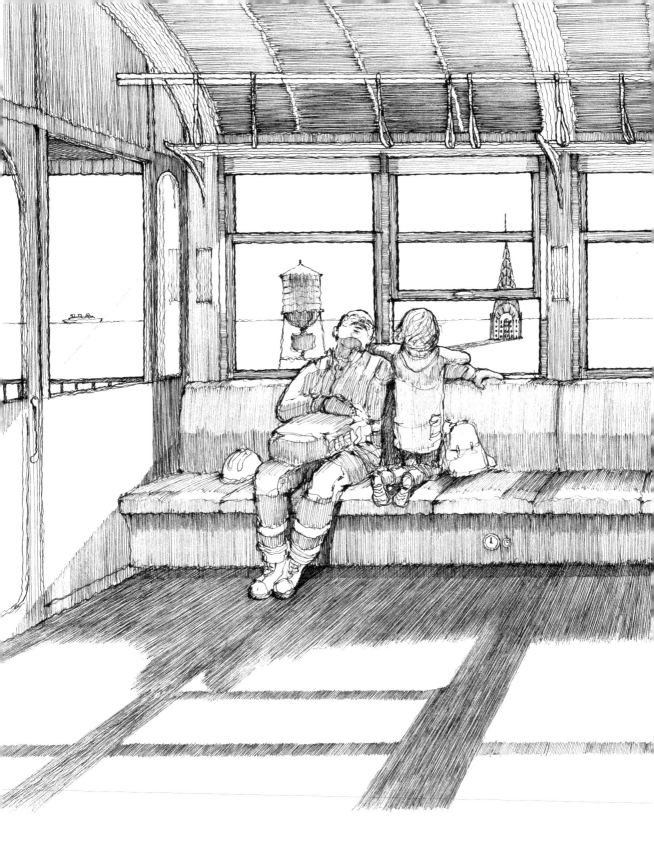

The journey home was long.

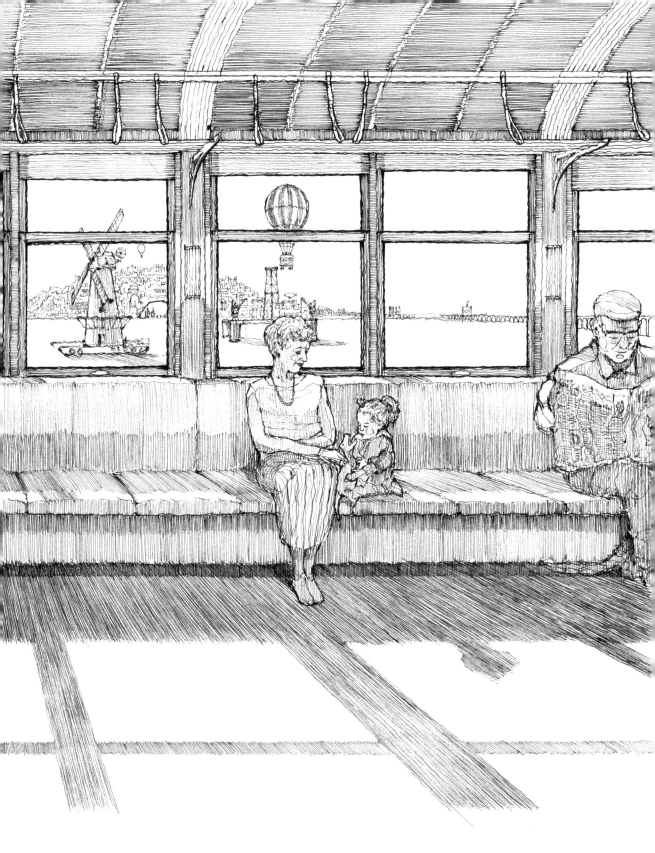

Olive watched as the world passed them by.

Olive was her father's world.
She felt weightless on his shoulders.

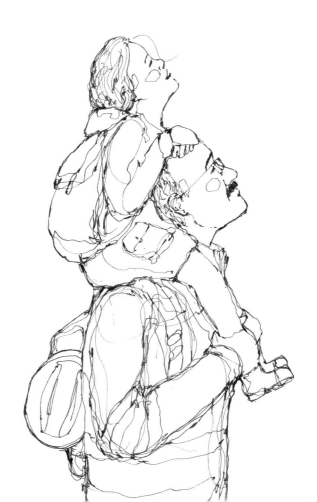

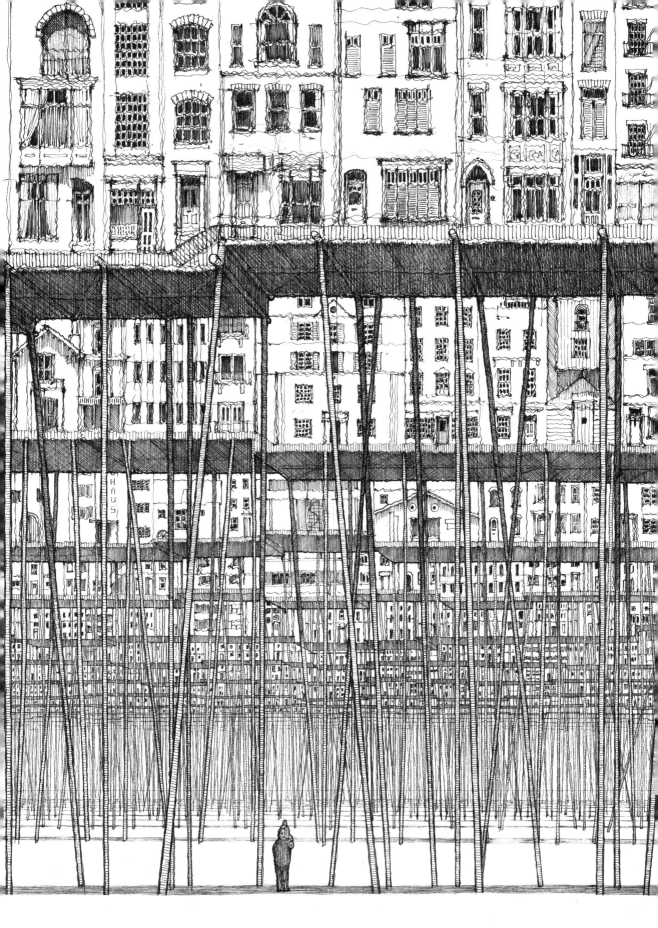

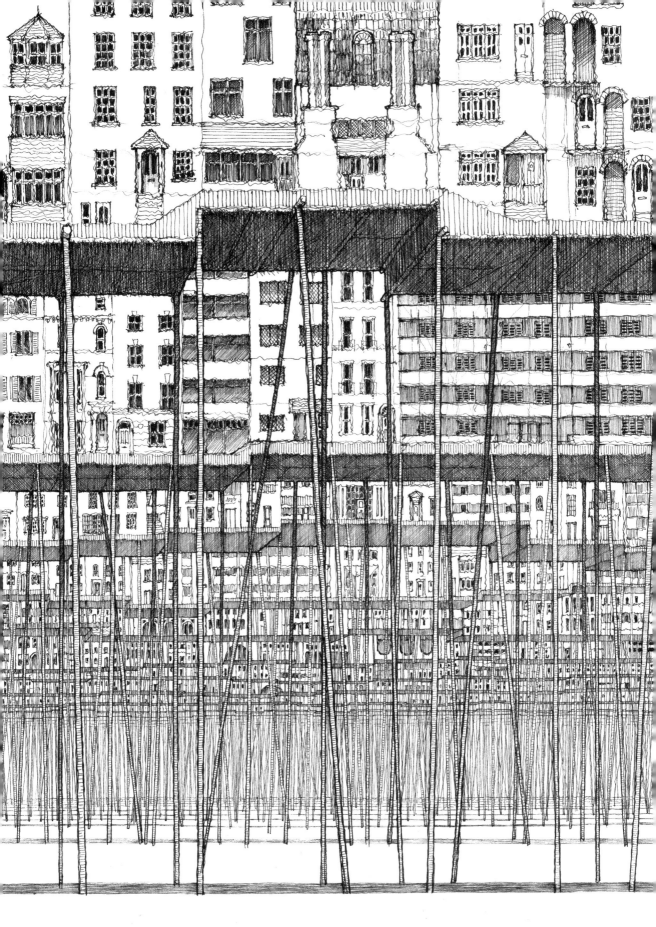

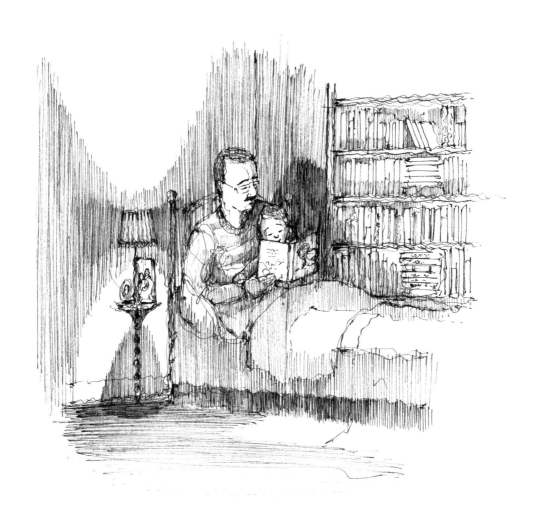

The train brought them home, but books could
take them anywhere they imagined.

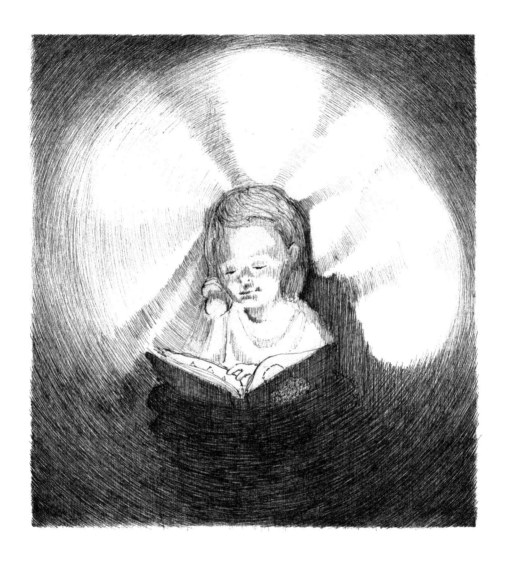

Tonight, Olive couldn't sleep.
Tomorrow was her first real adventure.

The Tree Museum was built many years ago,
by the last of the Tree Generation.

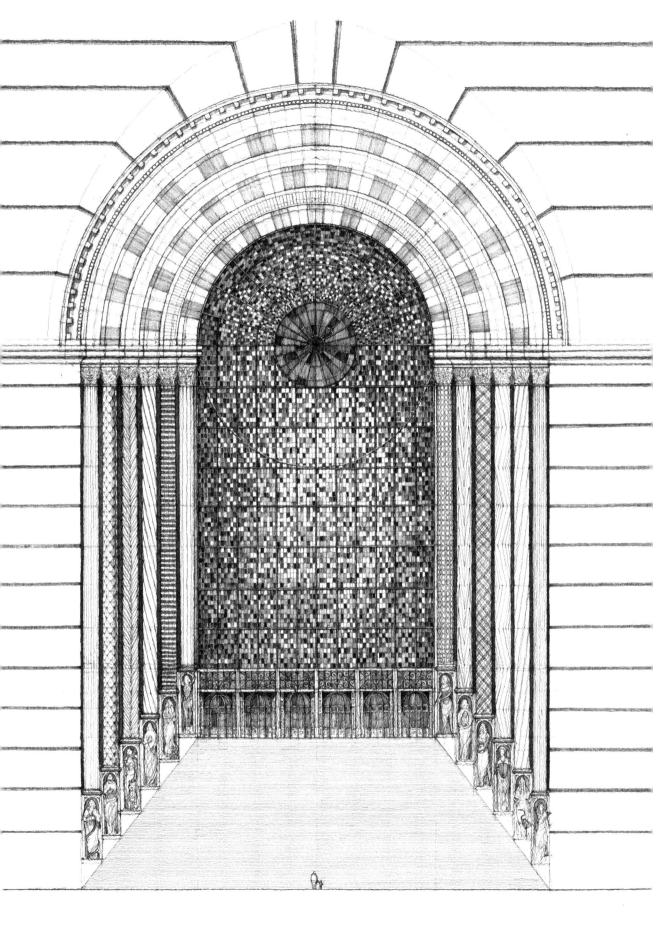

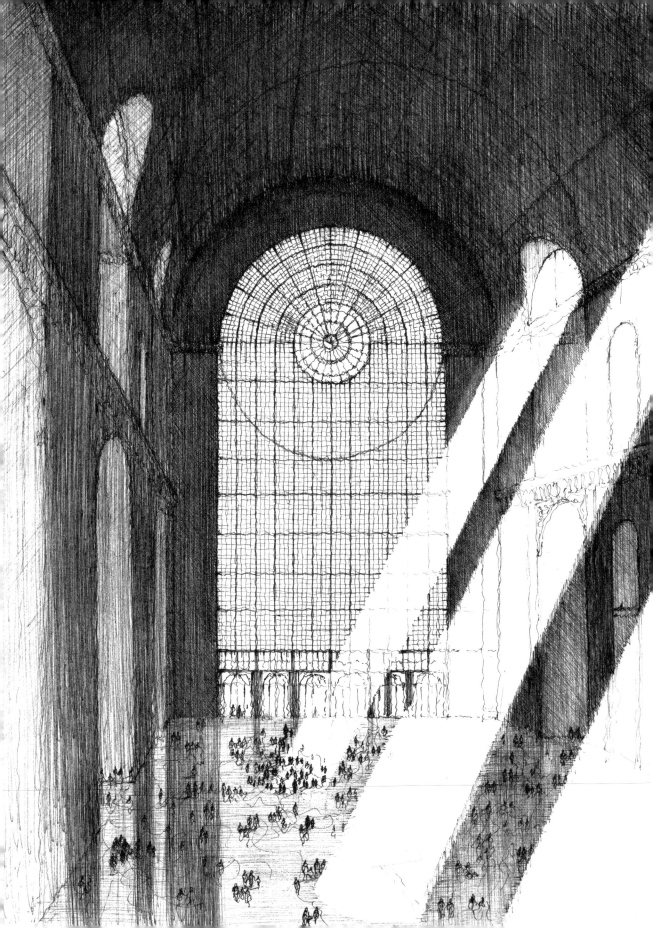

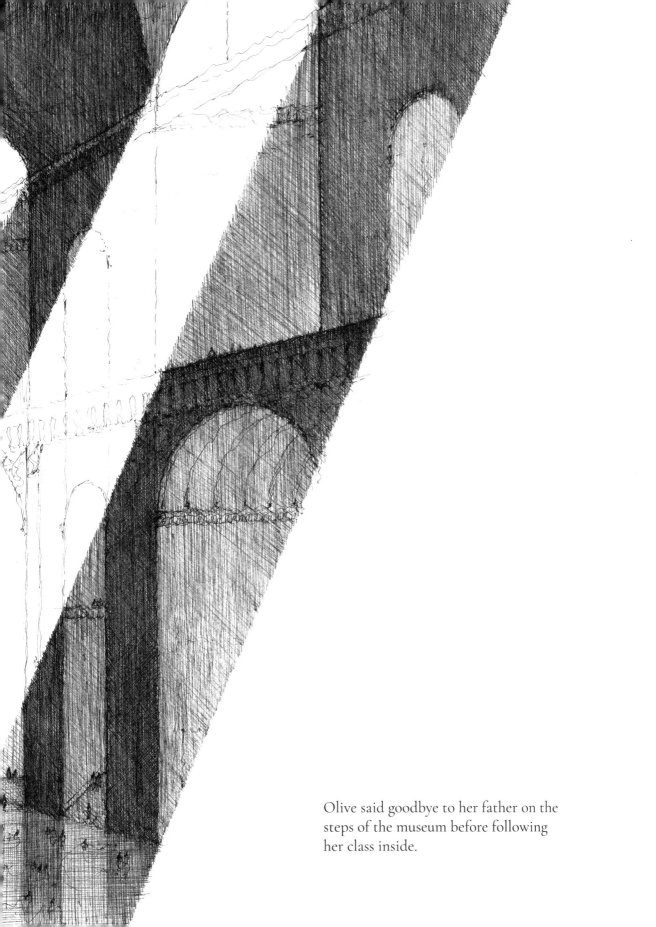

Olive said goodbye to her father on the
steps of the museum before following
her class inside.

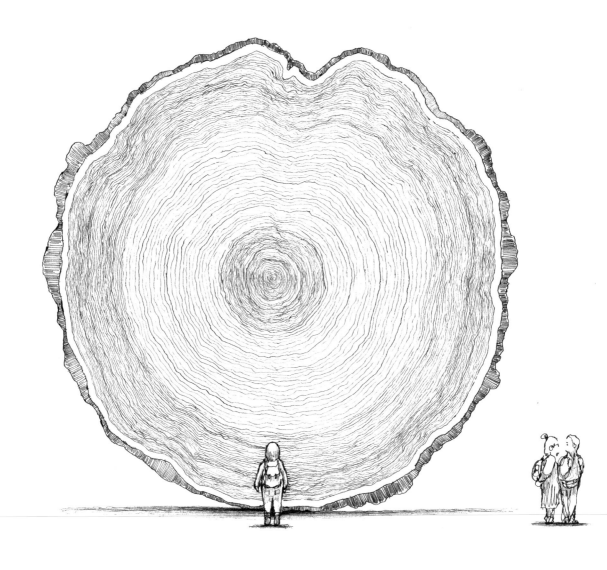

For as long as Olive could remember,
she had longed to meet a tree.

But the last of the trees
had died long ago.

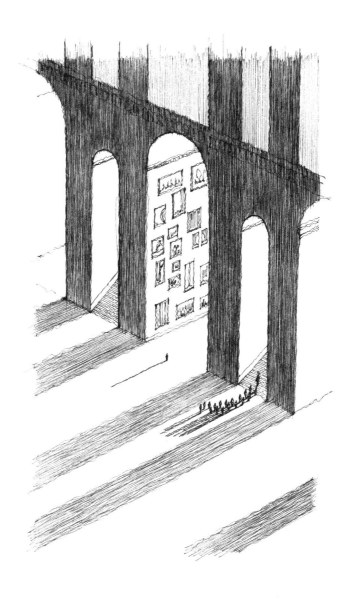

It was a painting that caught her eye,
and Olive found she couldn't look away.

She whispered its name:
'*The Last Tree*'.

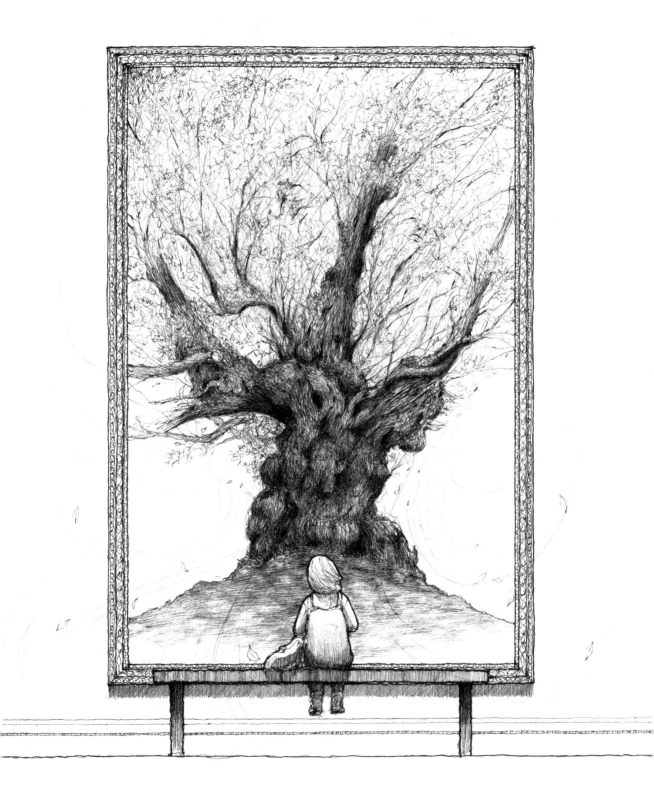

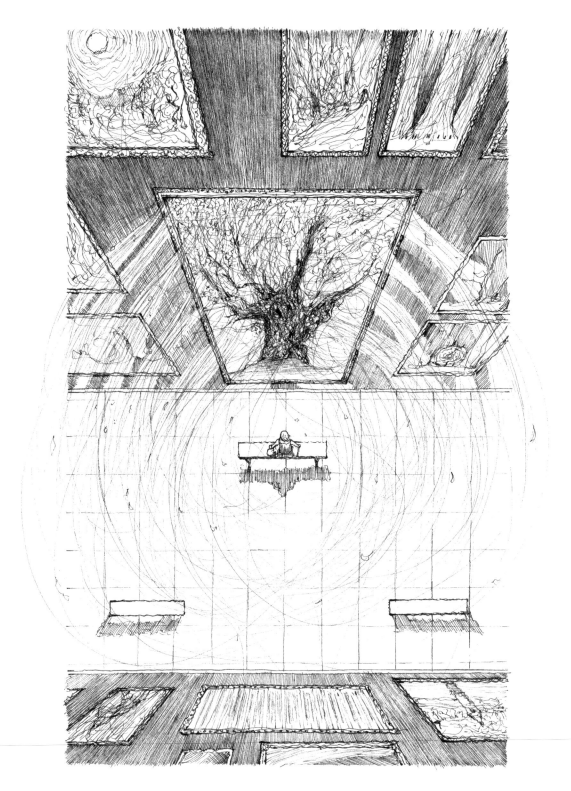

And the tree whispered back.

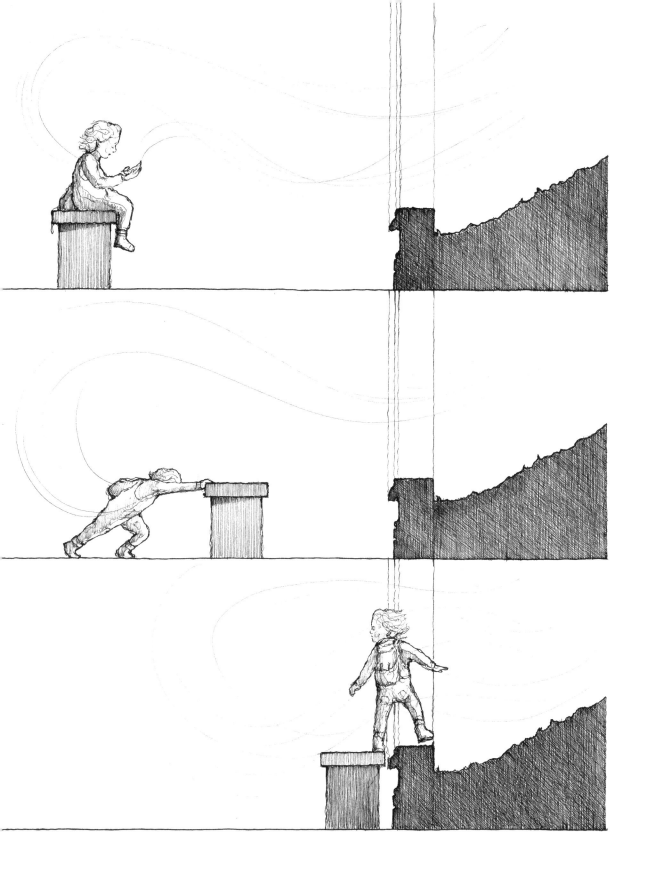

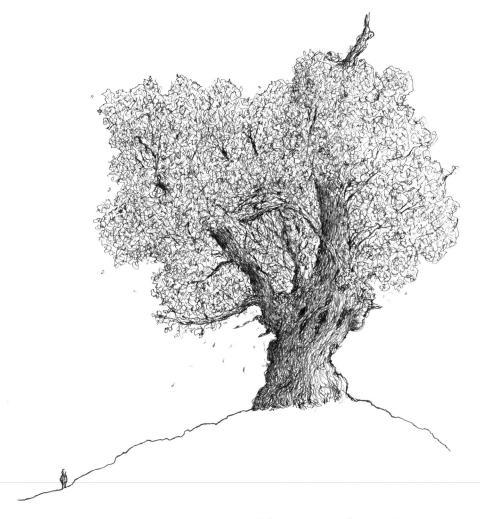

Olive was lost for words.

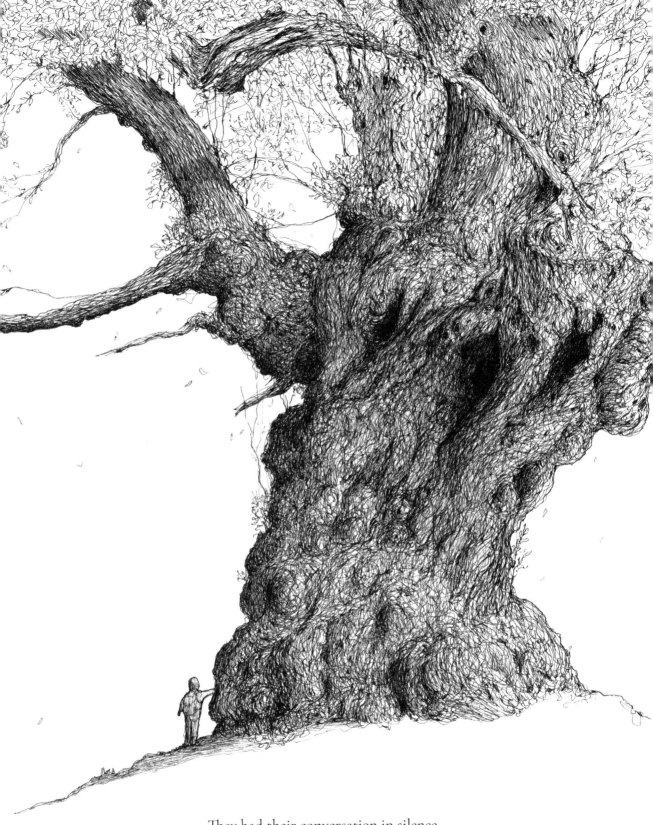

They had their conversation in silence.

She began to climb.

It was a long way up.

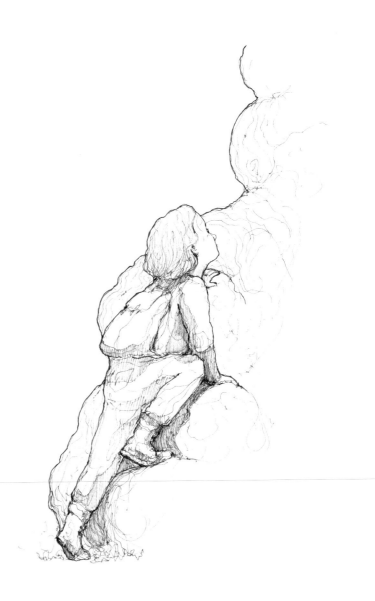

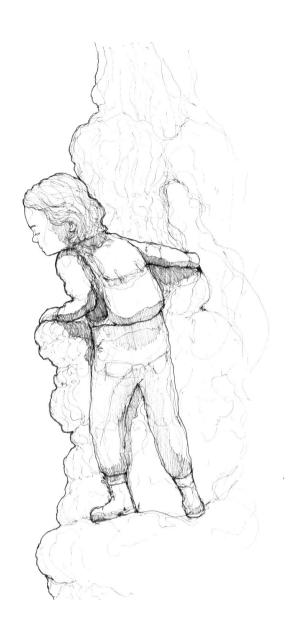

It was a long way down.

Sometimes, to reach the sky,
      you have to lose sight of the ground.

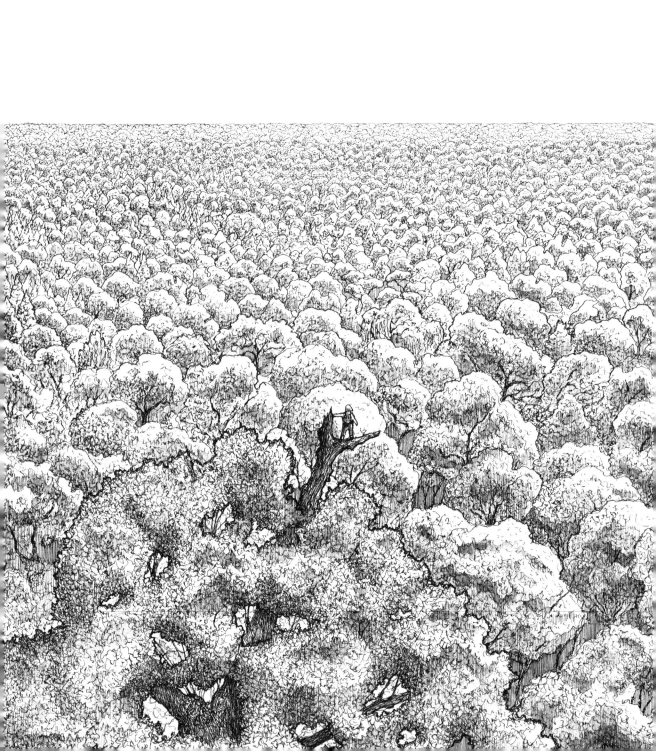

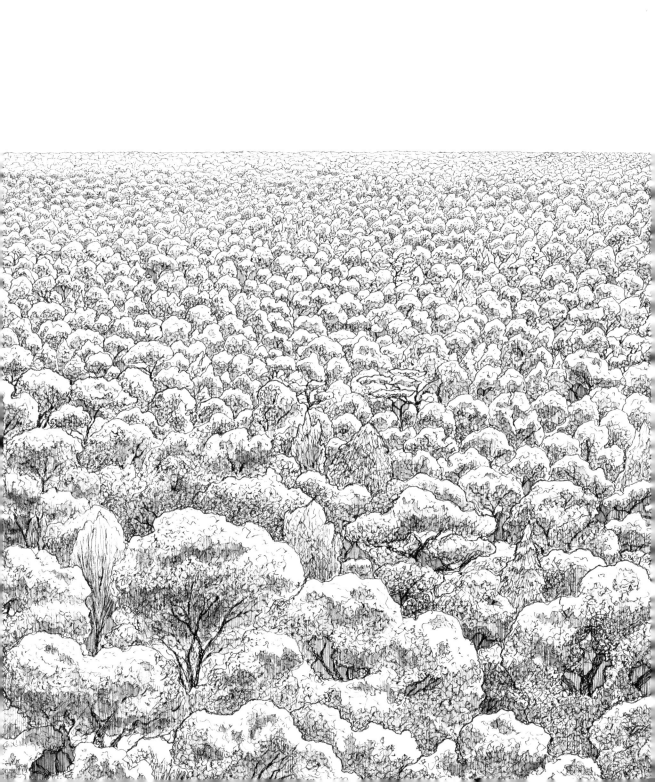

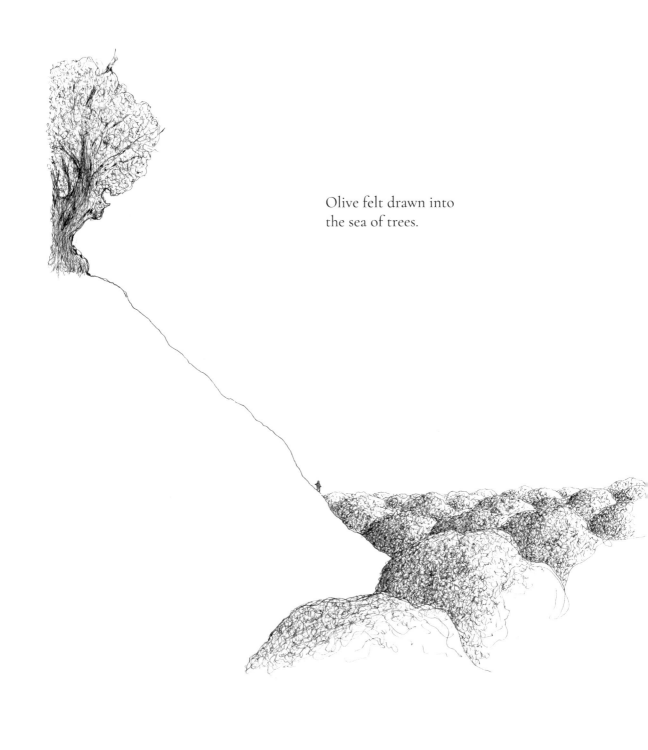

Olive felt drawn into
the sea of trees.

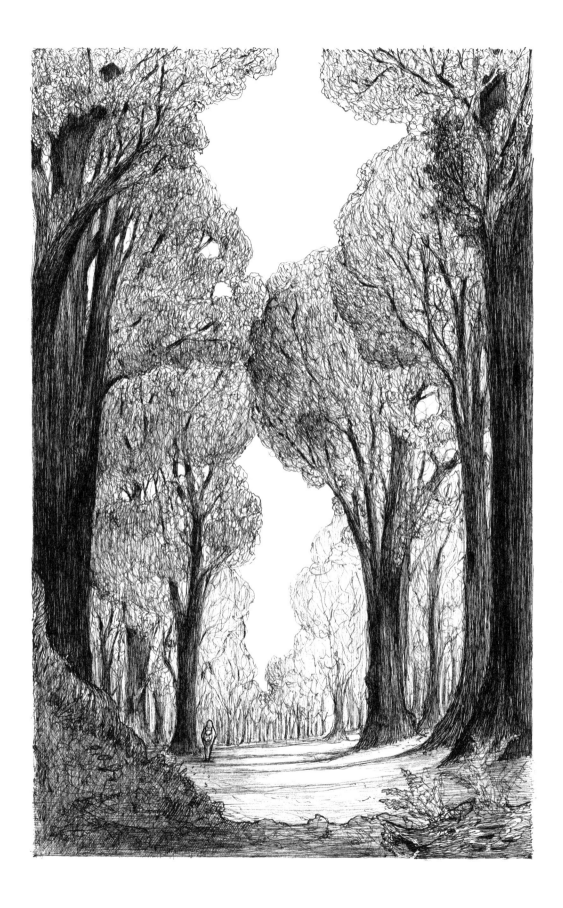

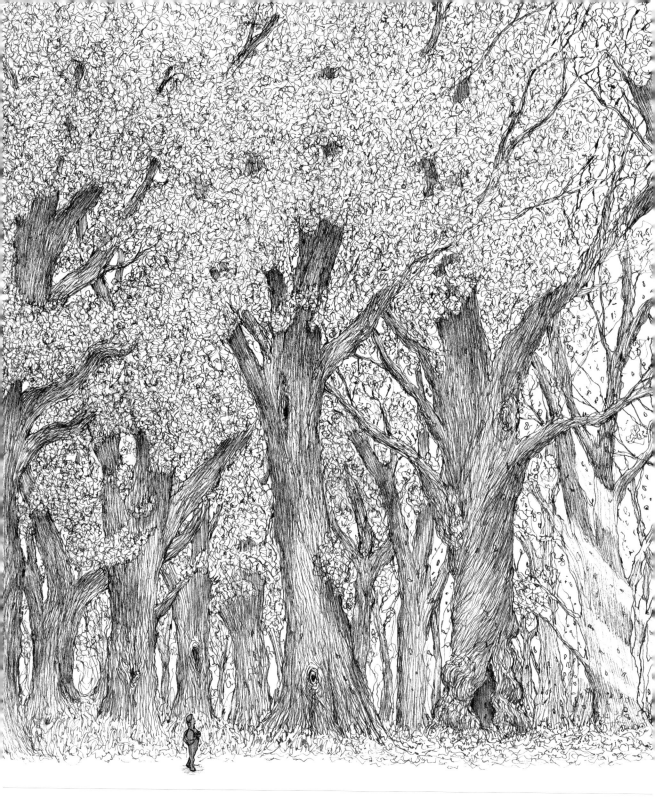

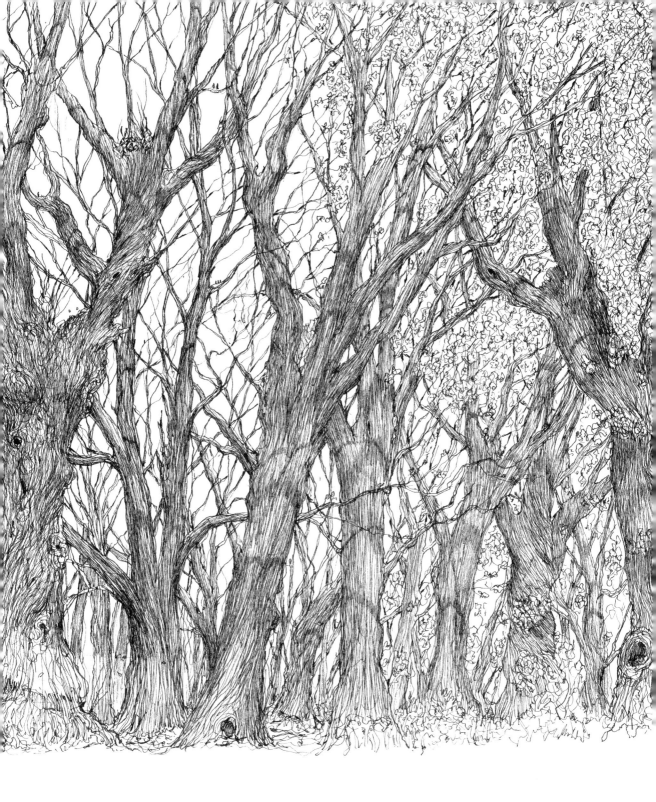

Time passed by differently here, counted in seasons not seconds.

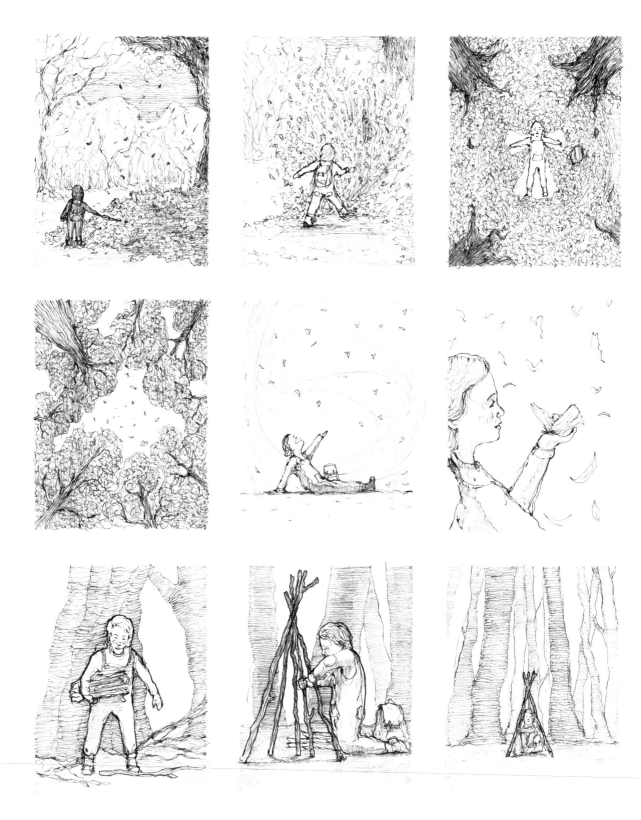

Deep in the forest, Olive was lost and yet found.

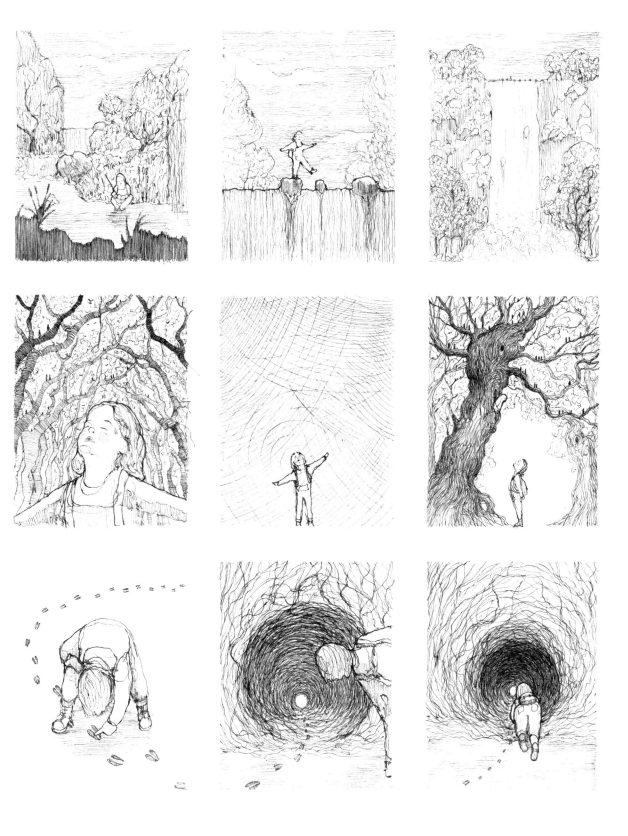

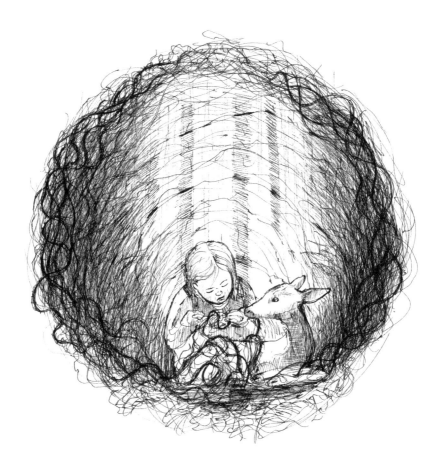

In time, she realised that she was not
the only one alone here.

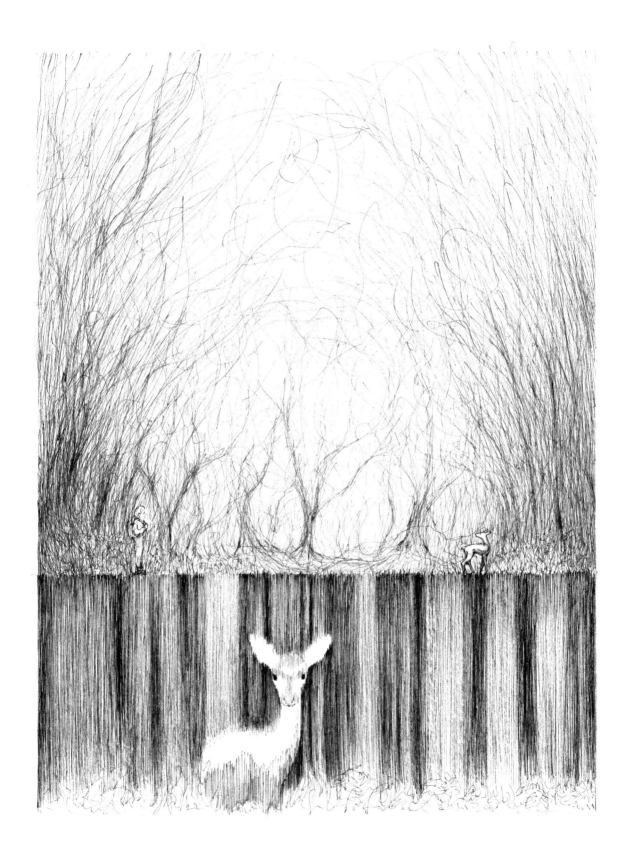

So this is how trees sleep,
thought Olive.

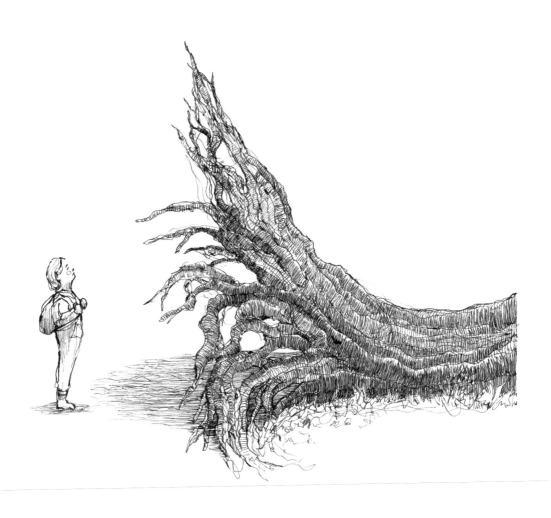

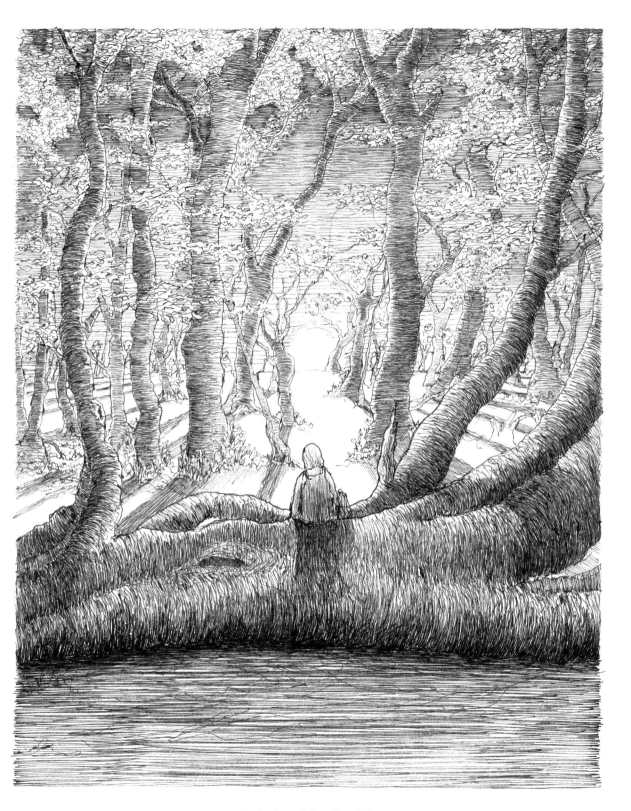

The light of the day fell away.

Olive looked up at the dark night sky,
only to learn it was filled with light.

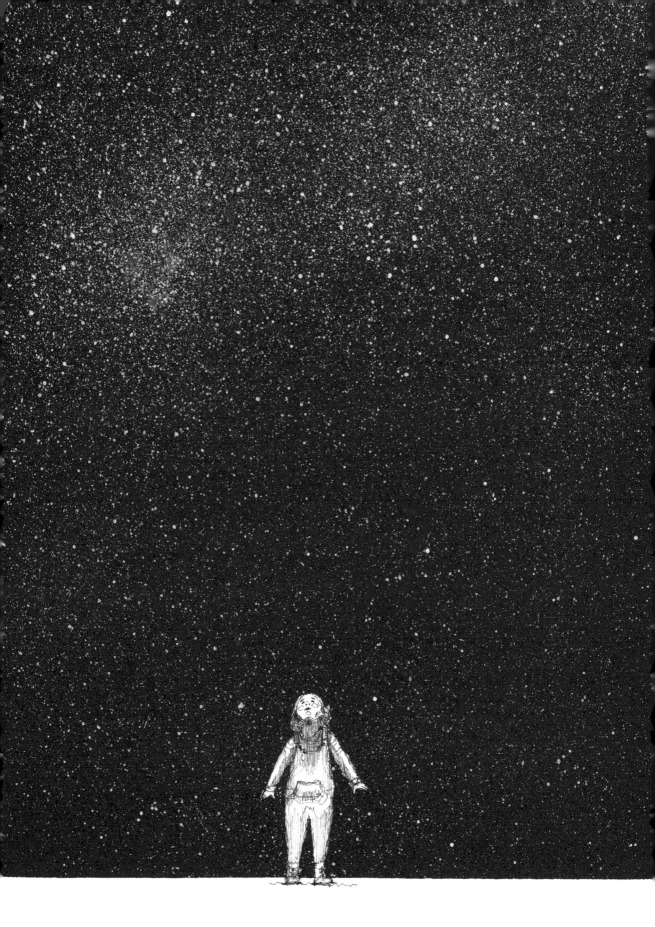

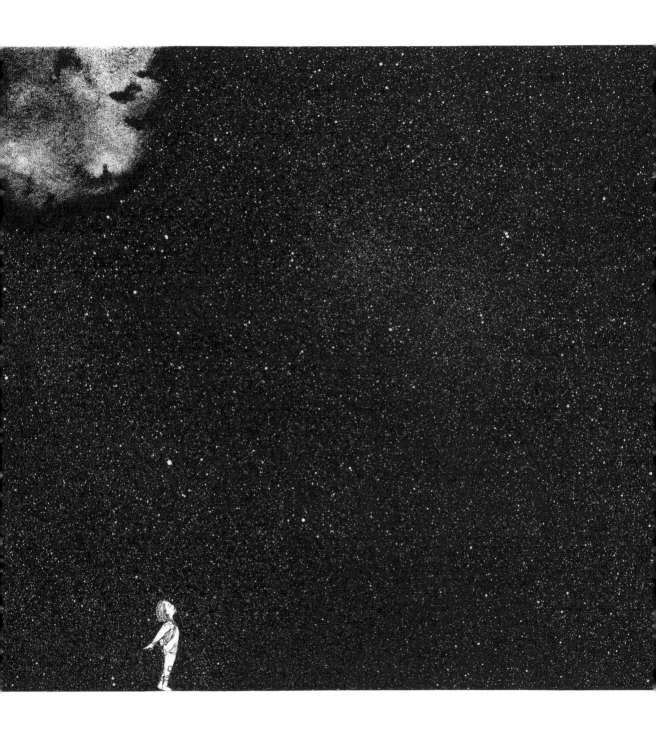

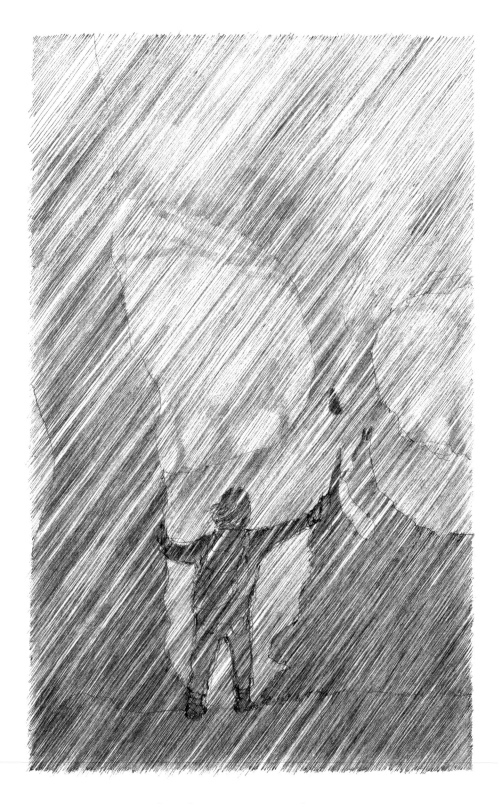

Clear skies may not stay that way.

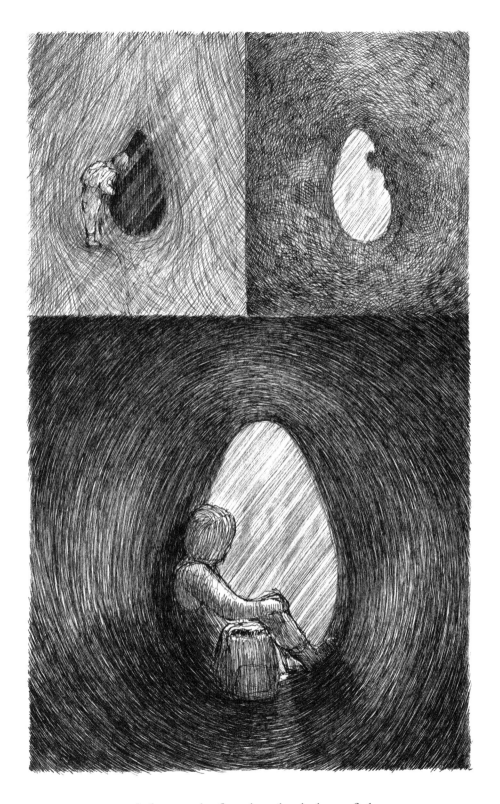

But shelter can be found in the darkest of places.

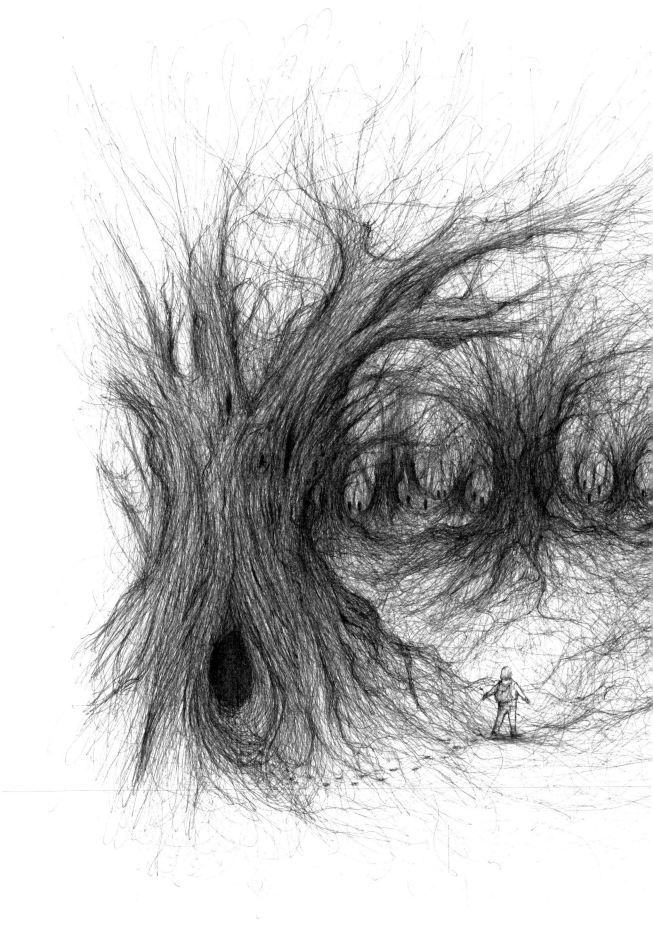

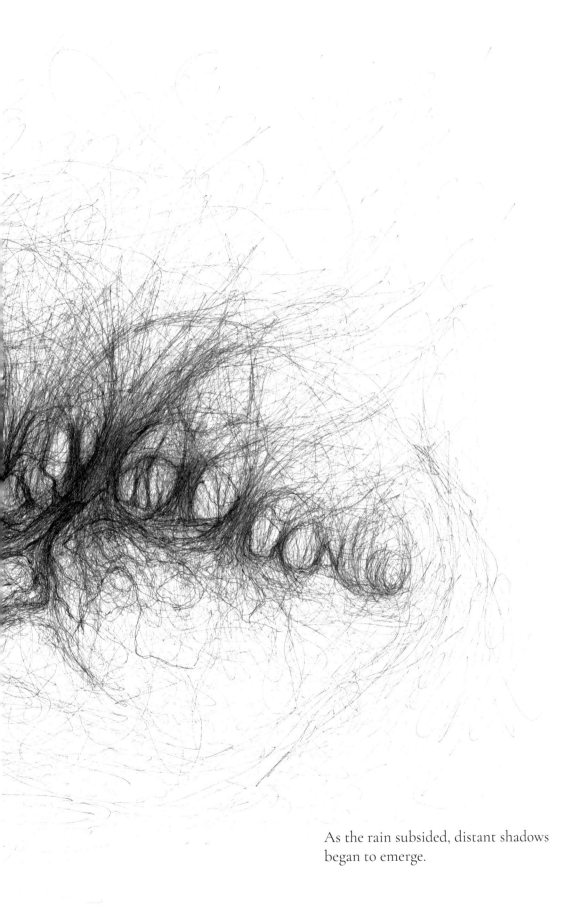

As the rain subsided, distant shadows
began to emerge.

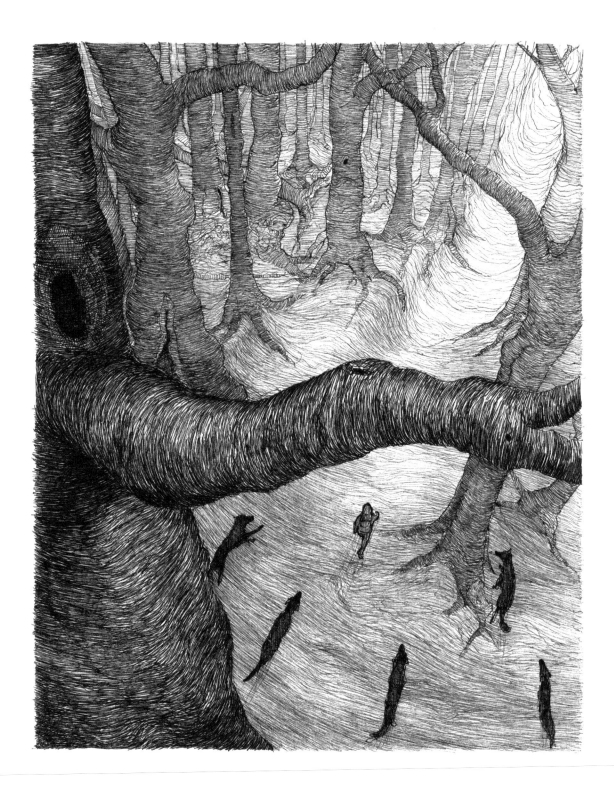

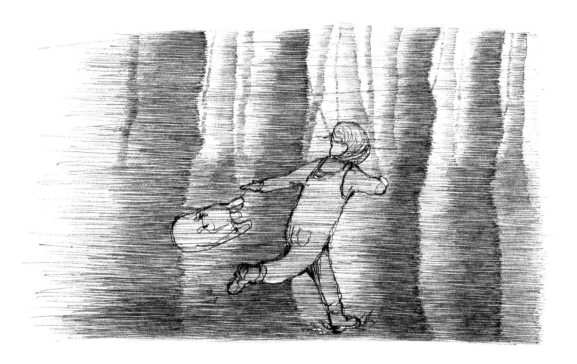

She ran as fast as she could.

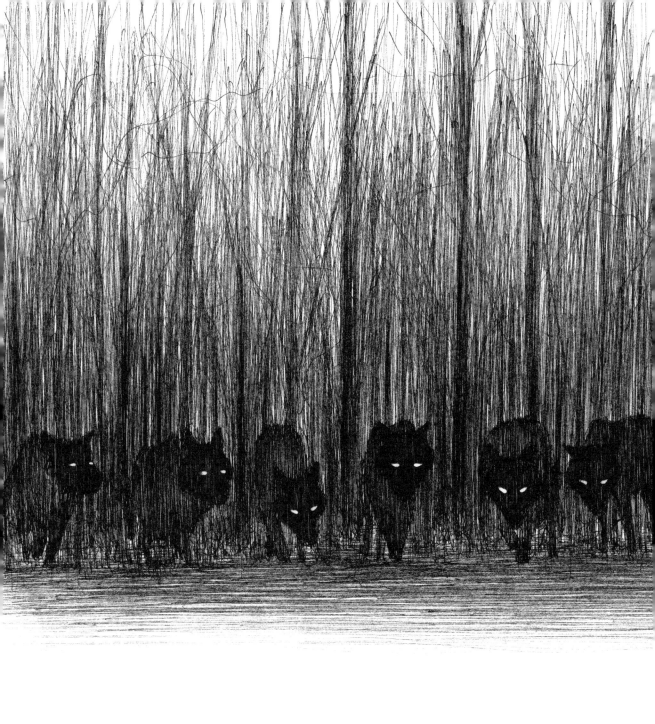

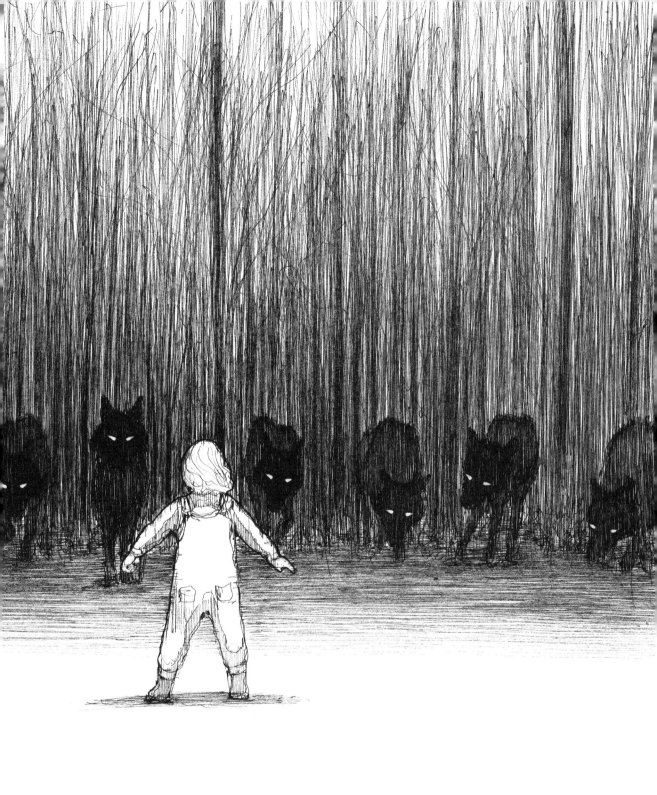

There are some things you can't run away from.

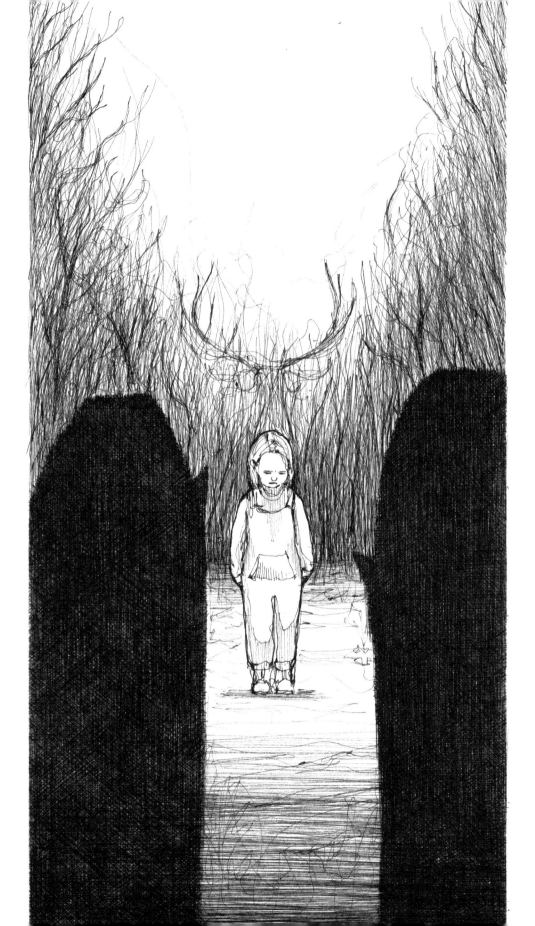

But fears need not be faced alone.

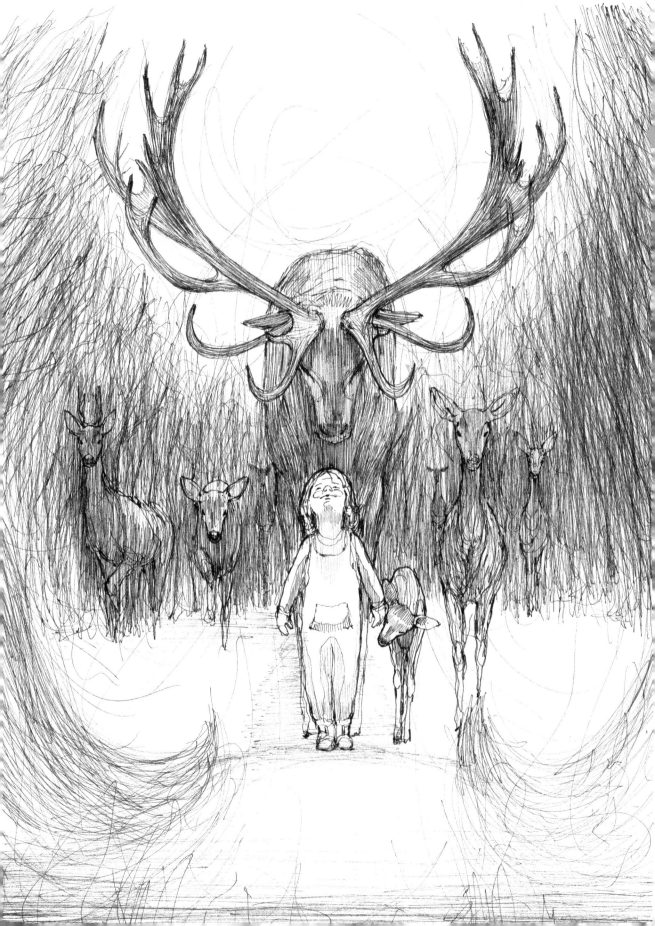

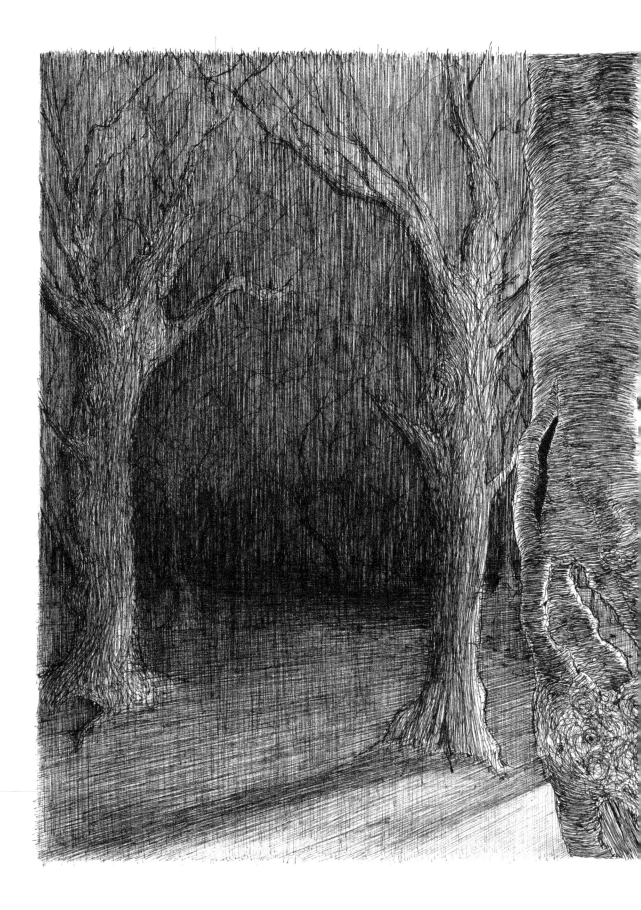

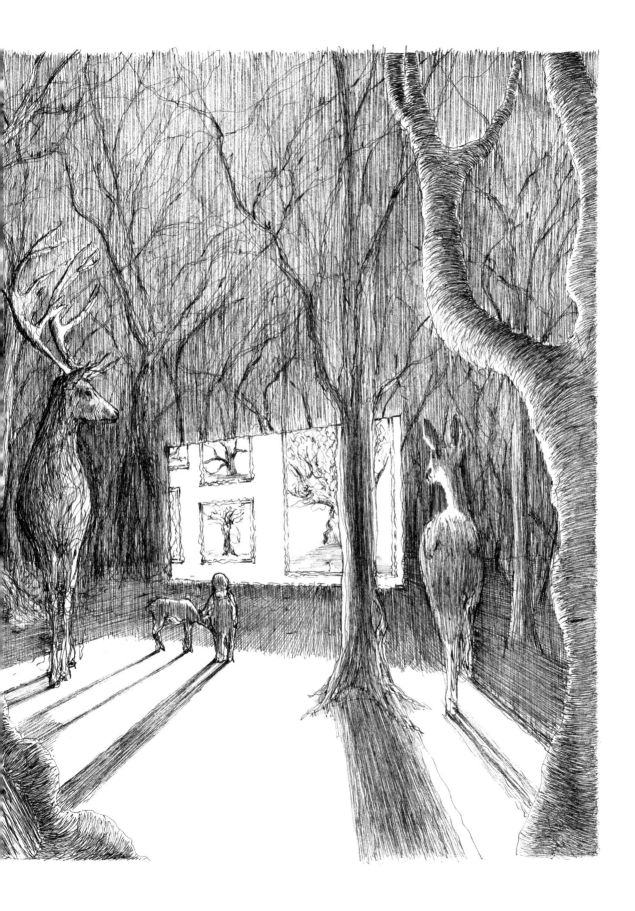

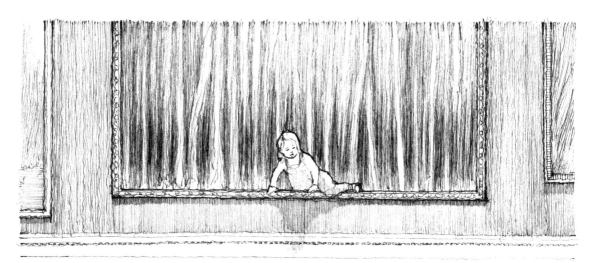
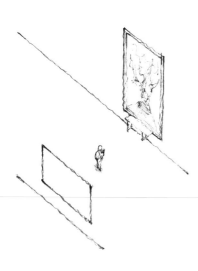

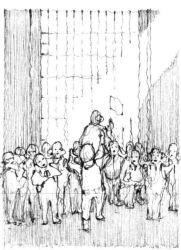

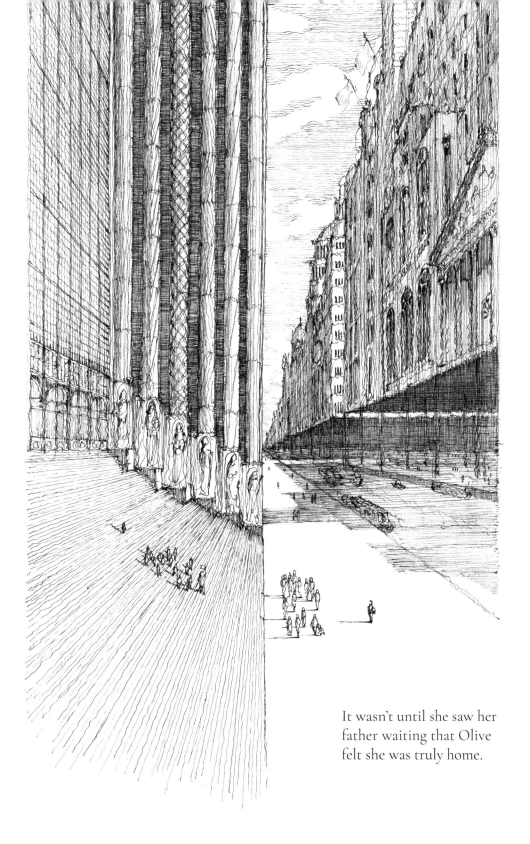

It wasn't until she saw her
father waiting that Olive
felt she was truly home.

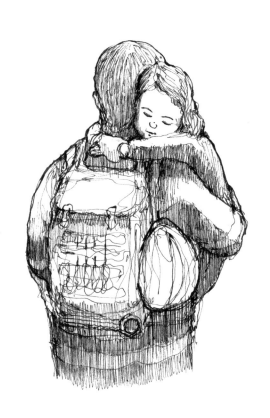

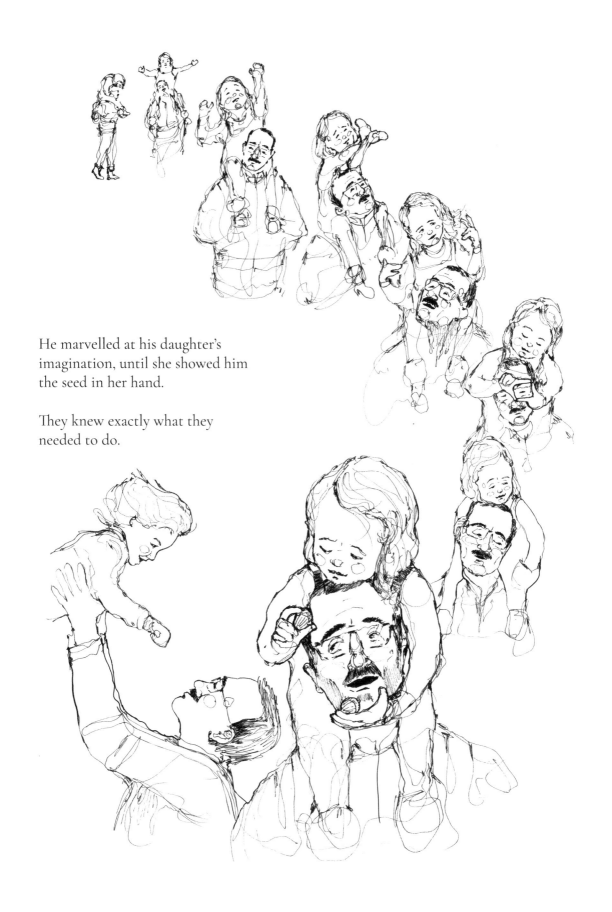

He marvelled at his daughter's imagination, until she showed him the seed in her hand.

They knew exactly what they needed to do.

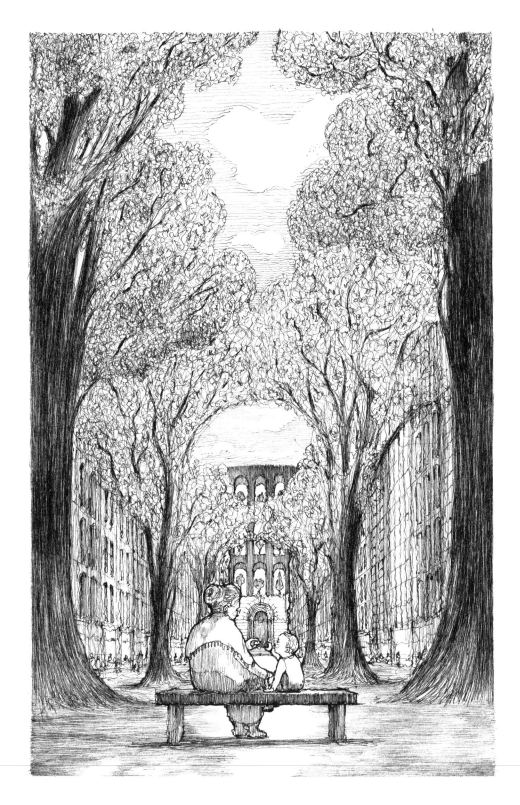

Time passed and Olive watched over her trees, as they
would watch over the generations to come.